Sister Wendy
on the Art of
MARY

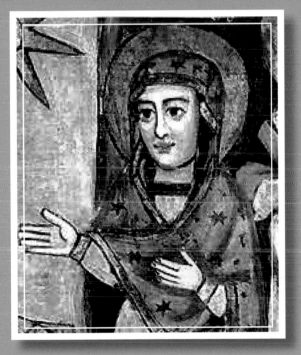

Sister Wendy Beckett

Franciscan
MEDIA
Cincinnati, Ohio

Original edition copyright © 2010, Redemptorist Publications.
First published as a series of *The Sunday Bulletin* from September to November 2009. First published in book form May 2010. The credits on page iv constitute an extension of this copyright page.

Cover and book design by Mark Sullivan. Sister Wendy image © Photoshot.
Cover image *The Mother of God as the Burning Bush*,
copyright © District Museum of Kolomenskoye, Moscow, Russia.

LIBRARY OF CONGRESS CATALOGING-IN-PUBLICATION DATA
Beckett, Wendy.
Sister Wendy on the art of Mary / Sister Wendy Beckett.
pages cm

Summary: "Imagine going on a tour of a world-class art museum with a talented and insightful curator. But instead of just focusing on the history, technique, and cultural significance of each piece, you have the opportunity to reflect on the spiritual aspects of the works, examining their religious significance and concentrating on the transcendental meaning conveyed by the artist. This is what you'll find in this exquisitely produced book. It features fifteen pieces of art relating to Mary, with an extended reflection on each piece. The commentary is meditative, more reflection on the spiritual nature of the paintings' subject than art critique. Sister Wendy writes with the deft hand of one who is formed in spirituality, art, and critical thinking. Her imagery is lush, creating a landscape where the sacred and profane live in comfortable coexistence through the medium of painting. For spiritual seekers and lovers of art, this book will offer a unique journey into the experiential nature of a well-rounded faith"— Provided by publisher.

ISBN 978-1-61636-693-3 (pbk.)
1. Mary, Blessed Virgin, Saint—Art. 2. Mary, Blessed Virgin, Saint—Mediations. I. Title.
N8070.B375 2013
704.9'4855—dc23
2013018830

ISBN 978-1-61636-693-3

Published by Franciscan Media
28 W. Liberty St.
Cincinnati, OH 45202
www.FranciscanMedia.org

Printed in the United States.
Printed on acid-free paper.
13 14 15 16 17 5 4 3 2 1

Contents

Picture credits

The Conception of St. Anne, Novgorod, fifteenth century
 Copyright © Ikonen-Museum, Recklinghausen, Germany
The Nativity of the Virgin, Pskov, fourteenth century
 Copyright © P. Korin Museum, Moscow, Russia
The Presentation of the Virgin in the Temple, Angelos, first half of the fifteenth century
 Copyright ©Byzantine and Christian Museum, Athens, Greece
The Annunciation, c. 1120
 Copyright © The Tretyakov Gallery, Moscow, Russia
The Nativity of Christ, Latygava Village, Vitebsk region, 1746
 Copyright © National Art Museum of the Belarus Republic, Minsk, Belarus
Presentation of Jesus at the Temple, Andrei Rublev and assistants, 1408
 Copyright © Russian Museum, St. Petersburg, Russia
The Wedding Feast of Cana, sixteenth century.
 Copyright © Vologda State Historical, Architectural and Art Museum, Russia
Christ "Not Painted by Human Hand" and "Do Not Weep for Me, Mother," school of Moscow, c. 1570
 Copyright © District Museum of Kolomenskoye, Moscow, Russia
The Ascension of Christ, ninth or tenth century
 Copyright © Monastery of St, Catherine, Mt. Sinai, Egypt
The Mother of God as the Burning Bush, Monastery of Solovki, sixteenth century
 Copyright © District Museum of Kolomenskoye, Moscow, Russia
The Virgin of the Sign, mid–sixteenth century
 Copyright © State Historical Museum, Moscow, Russia
The Virgin of Bogoliubovo, Monastery of Solovki, 1545
 Copyright © The Kremlin Museum, Moscow, Russia
The Vision of St. Paul, c. 1579
 Copyright © Museum of History and Art, Sol'vycegodsk, Russia
Christ Enthroned, sixteenth century
 Copyright © The Tretyakov Gallery, Moscow, Russia

INTRODUCTION

We are all born and each of us will die: Those are the two certainties of life. In between these certainties God has given us the gift of time so that we may grow into the fullness of what we are meant to be. This fullness is different for each of us, but the ways in which it is achieved are the same.

Since God made us in his own image and we know what that image is through the historical actuality of Jesus, each person's fullness is an attainment of a likeness to our Blessed Lord. When we are as God wants us to be, we will have within us what St. Paul calls "the mind of Christ." We learn this "mind" most of all by prayer, silent prayer, and the wonder of sacramental prayer. We learn it through reading the Scriptures where God reveals himself in his Son, and, complimentary to that, we come close to Our Blessed Lord in the books written by those who have understood the Scriptures.

Yet prayer, worship, and reading are only a part of our day (though, literally speaking, everything is or should be prayer). One of the most neglected truths is that we learn to become like Jesus through the actual process of living. God is giving himself to us all the time; but all too often we do not see it. He gives himself in human relations, in nature, in literature, in music, in art. This book is an attempt to show how he gives himself to us in art.

Artists have an awareness of something greater than themselves, as do most of us. The crucial difference is that they can make this awareness visible. Art draws us out of our own smallness into what one could call a vision for which there are no words. We experience it through the artist's skill, but to reach this experience we have to look very closely at what the artist has done.

In many of the works I have chosen, what the artist puts before us flows from a scriptural narrative or some other aspect of faith. We cannot encompass the liberating power of the vision unless we understand the essential elements of the story. Looking closely and letting the work reveal itself to us is a paradigm of all looking. How are we to seek God if we do not look?

Once we have learned the deep joy of looking at art—which can also be an alarming challenge, when we see things in ourselves that we would rather not see—we are emboldened in our looking at the life in which we are embedded.

One of the verses of Scripture that moves me most deeply is the great cry with which Jesus died on the cross: "It is consummated." He

had fulfilled completely the will of his Father. He had never neglected or passed by that holy will, displaying itself in the most ordinary of circumstances.

None of us can come even near this wonder of "consummation." We have missed so much, not out of malice but through sheer ignorance and lack of interest. We do not take enough trouble, to paraphrase St. John Vianney. God was there but we did not see him.

When you look at the pictures in this book, really look, opening your heart to take in what is there before you, you are not only responding to a particular work of art, you are practicing the habit of openness to the beauty of God as he illuminates every moment of your every day. Understood correctly, appreciating and understanding art is a profound form of prayer. It changes us. Or rather, it will change us if we allow the Holy Spirit to utter within us the total yes of Jesus to the Father.

—*Sister Wendy*

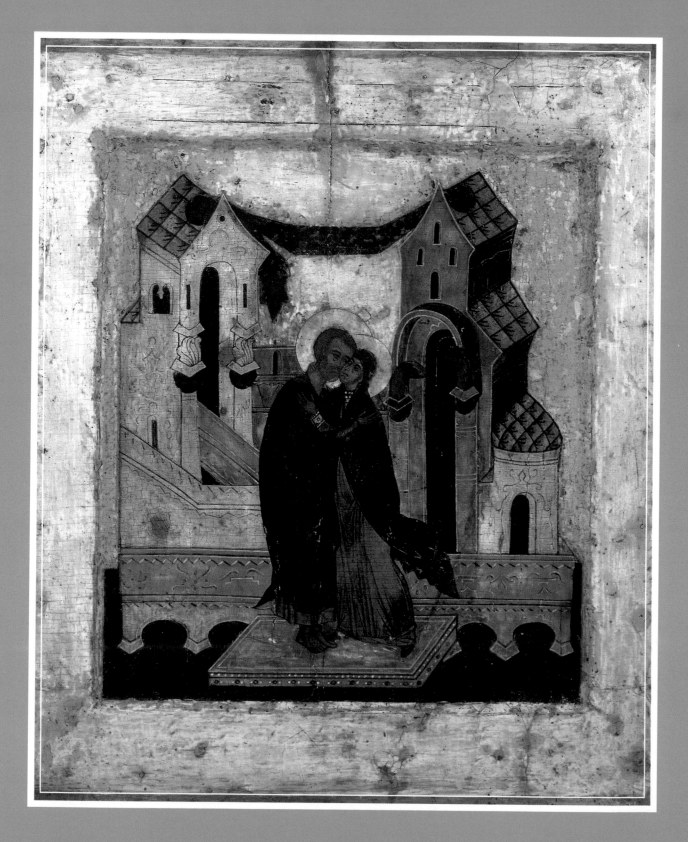

THE IMMACULATE CONCEPTION

The Conception of St. Anne, fifteenth century, Novgorod
Ikonen-Museum, Recklinghausen, Germany

It is very hard to portray an absence, but the Immaculate Conception is about precisely this: the absence of what we call original sin. Our Blessed Lady was conceived in the normal human fashion, but from the outset she was completely filled with the goodness and love of God. We all have to struggle with what we desire to be—wholly surrendered to God—and what we actually are: self-seeking and conceited. Our wills will not obey us. Mary's will was completely at her disposal; there was no struggle, only instant and spontaneous goodness.

The Gospels tell us little about Our Lady's background, but there is an apocryphal text called the *Infancy Gospel of James*. The Church did not accept it as a true Gospel, but the legend it told lived on. Our Lady's father, it recounts, was Joachim, who was rejected by the Temple when he came to make his offering, because he had no children. His wife, Anne, was past the age of childbearing. Joachim retired to the desert to pray; Anne lamented her sterility.

Then to both comes an angelic vision: Anne will conceive and they will have a child. Uplifted by the wonder of God's revelation, they meet together at what is known as the "golden gate." This icon shows the embrace at that meeting, cheek lovingly pressed to cheek, and Joachim's foot laid gently upon Anne's to symbolize sexual union. Her cloak flies wide to signify her openness to the embraces of her dear husband.

This image is actually called *The Conception of St. Anne* because it portrays mystically that marital encounter from which Our Lady will spring. The red cloth linking the two buildings indicates that this embrace is taking place indoors. Out of delicacy, the icon cannot show the actual conception, that altogether natural act, but here we see the essence. It is fraught with mystery and significance. From this conception will come the beginning of our salvation. The artist shows Joachim and Anne standing on a suspended rectangle, not quite in this world. The child to be born will belong to the common world of us all, but, because she is to be the mother of Jesus, she belongs also to a heavenly reality.

Like her parents, Mary is a normal human being. But she shows us our own potential. Granted, God made her special from the start—she was immaculate from her conception—but it was what she did with God's gifts that give us such hope.

Each of us is different—different gifts, different desires, different circumstances. Others may have gifts and live in circumstances that we think are better than ours, but it is each one of us, you and me, that God calls to holiness. God calls us as we are, with all our deficiencies and difficulties. We were not conceived immaculate. No matter: We are what we are, and it is only when we accept our own reality, as Mary accepted hers, that God can draw us into his fulfillment.

God gave a special privilege to his mother, and we can see why: The flesh from which Jesus was born should not know the taint of selfishness. But to each of us God gives something different. Mary's sinlessness is there to support us in our sinfulness, to help us grieve and change and accept the overflowing grace of her son. Anne and Joachim were despondent. They turned to God, and God drew them into an unimaginable bliss. Jesus is there to do the same for us.

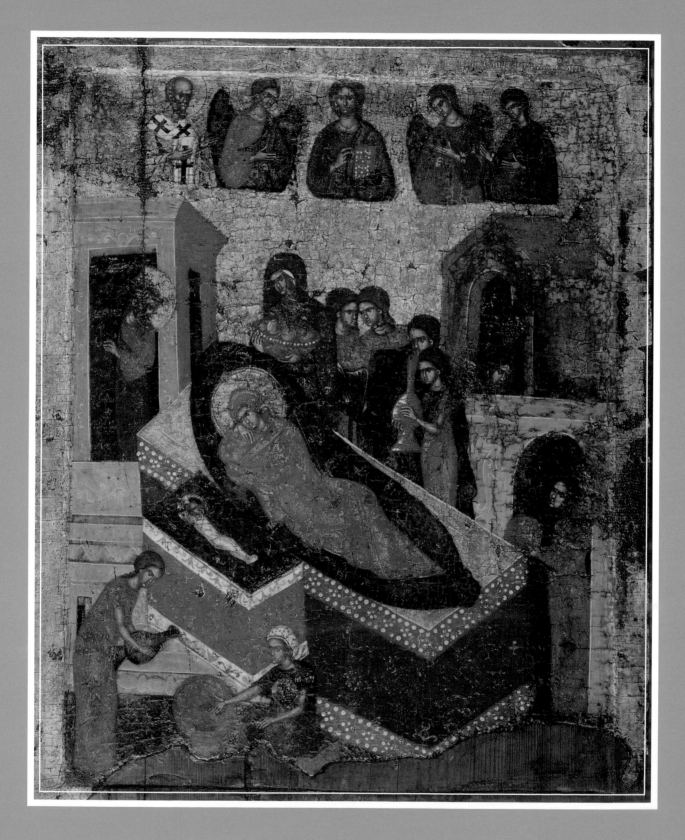

THE BIRTH OF MARY

The Nativity of the Virgin, fourteenth century, Pskov
P. Korin Museum, Moscow

The early Church simply could not accept the reticence of the Gospels about Our Blessed Lady. Even though they recognized that the *Infancy Gospel of James* was pious legend, it was still dear to them as a way of expressing the significance to the world of Our Lady. They imagined her conception—a blissful Anne and Joachim at the golden gate—and they imagined her birth.

The picture imagines rather upper-class surroundings, with Anne on a large and costly bed and countless ladies clustering around to offer their admiration and congratulations. In the foreground we see the maids preparing a bath for the newborn child and on the left we see the proud father, peering in to catch sight of his wife and newborn daughter.

Amid all this jubilation, Mary is a slender wisp of a child, like the first faint brightness that will announce the dawn. The unknown artist shows above, as if we are seeing into heaven, the mature Jesus

surrounded by angels and saints, contemplating this scene and raising his hand in blessing. In a magnificent rejection of earthly chronology, we see the adult Mary herself holding up her hands in wonder at the working of God's grace.

The birth of Jesus was heralded in the sky, with angels summoning the shepherds, and a star summoning the wise men, the Magi. The prelude to that holy birth, the birth of Mary, took place in utter secrecy. No one noticed, no one recorded. The icon painter, like the James who wrote the infancy Gospel, is imagining what might have happened. Yet it did happen; Mary was born and, although nobody took any interest or marked it down as important, without this birth the Lord could not have come to us.

All too often, it seems to me, we feel that things are only important if they are noticed. But Jesus in the Gospels tells us that we should not let one hand know what the other hand is doing. He criticized prayers that were said in public for people to notice, alms that were given when there was to be a feedback of admiration. He told people to go into their rooms and pray to their Father "in secret," and that their Father, "who sees in secret," would reward them.

Prayer in public, liturgical prayer, is essential, but the motive should never be personal or selfish. It is not what people see that matters, but

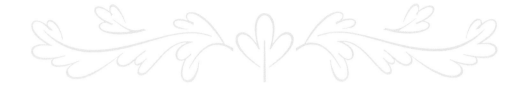

what we are, what our heart desires. Apparently, no one witnessed the birth of Mary, but God did. God valued her as what she was and what she was to become.

We want to be seen, to have the affirmation of others. Our Lady and her parents lived without this. It was what God thought that mattered to them, what God wanted. Anne and Joachim did not see, there in the sky above her bed, Jesus and the angels. They did not see the theologian in the top left-hand corner of the picture, who would write about Our Lady; neither did they see Our Lady herself, a vision of the future, in the top right-hand corner, rejoicing in God's goodness to her. Yet everything we do, God sees and blesses. God our Father is aware of our least impulse toward love. He stretches out his hand when we falter, he blesses and exults when we say yes to what life demands.

Children, in their insecurity, often need adult approval. Like Joachim and Anne, we are not children. We are baptized Christians, called by grace to look toward God alone and to do what seems right to us, no matter the circumstances. We have the sacraments, we have the Mass, we have the fullness of the New Testament. With the support of such grace, we are able to live without the approval or even the notice of the world around us.

THE PRESENTATION OF THE VIRGIN IN THE TEMPLE

The Presentation of the Virgin in the Temple, first half of the fifteenth century, Angelos

Byzantine and Christian Museum, Athens

The early Church could not bring itself to believe that Mary led a completely unremarkable life in the little town of Nazareth. Having imagined names for her parents and the circumstances of her birth, the early writers then went on to give her an astonishing childhood.

The story had it that Israelite virgins of special virtue and beauty were taken to the Temple where they were instructed and given the privilege of weaving the high priest's robes. Not only was Mary, naturally, chosen to be of this elite band, but she was elected when she was only three years old. The tale went on to tell how the toddler walked alone and unaided up the Temple steps, to the astonishment of the high priest and the bystanders.

Here we see the small Mary, although the great flight of steps has been diminished, for artistic purposes, to merely two. Her maturity and self-possession are amazing to the high priest, who bends down affectionately to the child, one hand hovering protectively above her halo. The little Mary opens her hands wide, offering herself to God, an offering which we believe she did indeed make.

Behind her Joachim and Anne, her parents, repeat this offering, well aware of the uniqueness of their daughter. Behind them, holding candles,

9

flock a procession of the Temple virgins (those mythical creatures). They are dressed in the height of fashion, and their sophistication is in piquant contrast to the modest robes of Mary. Even Mary's head is covered—no glamorous hairstyle here—as her body language speaks only of her desire for God.

The red curtain at the back indicates that we are inside the Temple, and on the left, in the very heart of the building, we see an older Mary. The legend had it that her task was to weave the veil for the Holy of Holies and that she did this in an upper room of the sanctuary. The story told that she was reluctant ever to leave that upper room and so an angel came to feed her with the bread of heaven. We can see how so much of Christian life is being foreshadowed here. It was only at the Last Supper that Jesus instituted the Eucharist, giving us the bread of his body. Miraculously, prophetically, Mary is fed with an angelic bread that somehow foreshadows this Eucharist.

The idea that, because Mary was special, she must have lived a special life, comes naturally to us. Until quite recently, those who wanted to belong wholly to God would usually take it for granted that they were called to be priests or nuns. In fact, that was what *vocation* was taken to mean: a calling to an absolute service of the Church. I have always wanted to be a nun and I am sure that, for me, this was

the inevitable choice, but my thinking was clearly influenced by the conviction that in no other way could one love Our Lord completely.

We now know that this is not the mind of Christ. Everybody has a vocation and every vocation has, as its end, this same total love. The only difference is in the means. The mother and father, the ballet dancer, the postal worker, the doctor: All are called to receive the fullness of their being from Our Lord. The nun and the priest have no special advantages. If we have a religious vocation, it is because, for us, it is a need. Speaking personally, I am sure I am morally too weak to approach this blessed end (may it come nearer!) by any means other than the straight and narrow road of religious vows.

Mary did not need to be sequestered in the Temple and set to weave vestments for the high priest or a veil for the Holy of Holies. She was not dependent on circumstances but was drawn forward by the intensity of her desire. Each of us is in the circumstances that have come our way, making it either easier or harder to live by grace. If our circumstances are harder, then grace may flow more freely. Jesus died to make it possible for his grace to sanctify everyone; and our responsibility is to see what our actual life, in its day-to-day reality, asks of us.

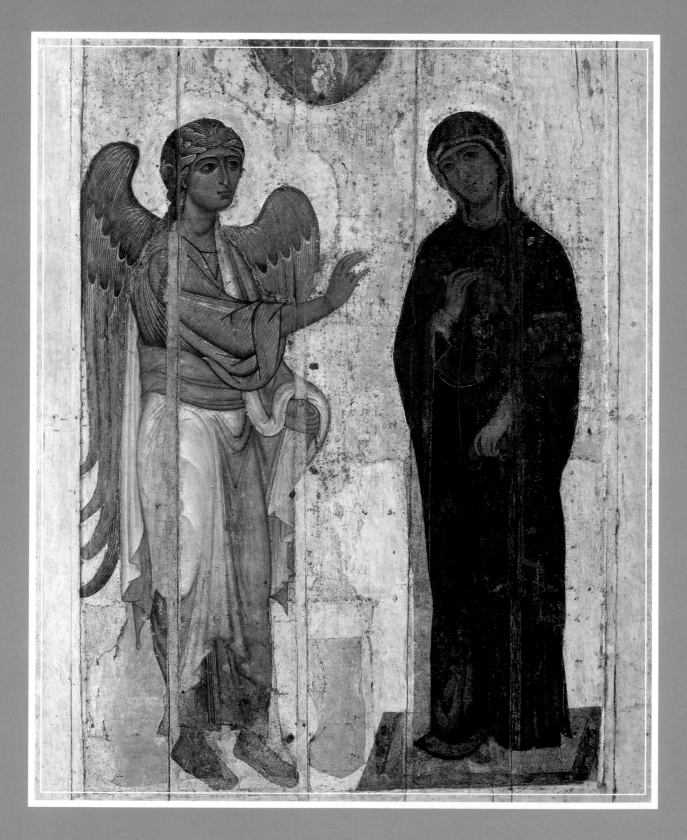

THE ANNUNCIATION

The Annunciation, c. 1120
The Tretyakov Gallery, Moscow

No one saw the annunciation, and yet perhaps no incident has been so repeatedly painted by artists and cherished by believers. This is a very large and ancient icon, taken from the cathedral in Novgorod and hung, like many sacred images, in the secular setting of an art gallery. It has lost none of its sacred aura, though, and draws us into the holy silence of this wonderful encounter.

The unknown icon painter portrays the archangel Gabriel as a figure of slow solemnity. He raises his arm gently, but emphatically, in blessing. Mary is not seated, as if to signify her constant state of attention to the messages of God. The blue-green color of her tunic is meant to indicate her human nature, while the dark red cloak symbolizes the majesty of royalty. She does not look at the angel. Her head is bowed as she listens. One hand almost instinctively replies to the angelic greeting, while the other is still holding the skein of scarlet thread from which she has been spinning the fabric of the Temple veil.

As we follow up the thread we can see, taking form within her bosom, the small figure of her embryonic child. Above, at the very top, is the Ancient of Days, the symbol of God the Father, and from that protecting presence to the Virgin there used to be a ray of light, containing the Holy Spirit in the form of a dove. We only know of this ray through earlier descriptions: The ravages of time have worn it away.

According to legend, the archangel Gabriel had visited Mary before in the Temple, where she sat lost in prayer in the inner sanctuary, but he had never spoken to her. Now, at last, time has come to its fullness, and the Father knows the world is ready to receive his Son. It is typical of God's humility that Mary is asked if she will be mother to Jesus, the second person of the Blessed Trinity. God asks; God will never impose.

It is impossible to overestimate what hung on the answer of this young woman. We know what the answer was—not merely a yes, but a trustful handing over of her future without conditions: "Let what you have said be done to me." We, who know the future, imagine she was well aware of the infinite importance of her "fiat," her "let it be done." But we hear later of Mary "pondering these things in her

heart" and there are hints that the fullness of the incarnation disclosed its meaning to her over time, rather than immediately.

Is this not true of us all? We can never fathom the significance of the responses that life puts before us. A choice made in all good faith may turn out disastrous, a slight miscalculation can balloon into the horrendous, our forecasts are inevitably fallible. Mary did not foresee the growing weight of responsibility. The rejection of her son and his terrible death were mercifully hidden from her. There would be long years in her future when Jesus was no longer physically present, and it was for her to support the frail and infant Church.

We are certain, though, that knowledge of the future would have made no difference to Mary's immediate response. Although she did not completely understand what was happening, she knew the question had been put to her by God. "My soul proclaims the greatness of the Lord," she would tell her cousin Elizabeth. She had absolute trust that whatever God wanted, God must have. Everything in every life is held in the loving providence of God. Joy and sorrow are both luminous with God, potential for love. The annunciation is essentially about trusting God and letting him do as he pleases with us, secure in his fatherhood.

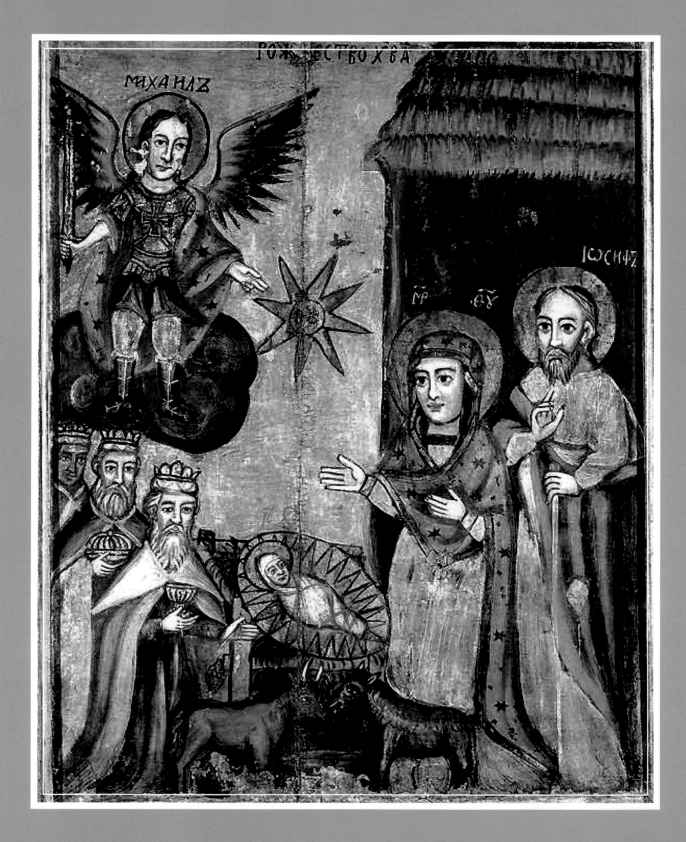

THE NATIVITY OF CHRIST

The Nativity of Christ, 1746, Latygava Village, Vitebsk Region
National Art Museum of the Belarus Republic, Minsk

The nativity is not just for Christmas. In fact, what with choosing and giving, buying presents, decorating a tree, preparing a festive meal, and welcoming family and friends, the actual season of Christmas may be too pressured for us to be able to contemplate this glorious feast. It is, of course, utterly the feast of Jesus, now at last revealed to the world; but there would be no Jesus without his humble, human mother. And so, whatever other elements of the full Christmas story are lacking in images of Christ's nativity, the painter will never omit the figure of Mary.

This particular picture is an example of primitive folk art, but it has a charm unique to its clumsy innocence. Belarus, from which it comes, was a part of Russia that suffered much violence, and perhaps appropriately the Christmas angel is stoutly clad in armor and carries a hefty sword. His boots rest on a cloud of ominous darkness. But Mary is quite unaware of her need for protection.

This is one of the few paintings that shows her smiling. St. Joseph, behind her, may be aware of danger, and the three kings, painted rather small to show their relative unimportance, may look rather glum, but the mother's whole joy is in her child. The little Jesus is tied up like a precious parcel with glorious red ribbons, and his crib, though floating at a rather awkward angle, radiates points of brilliance. Least important in the picture, down at the bottom, a very small ox and ass exchange glances of amazement.

The peasant artist paints Mary in pale blue and in lightest pink, the same color as the angel's robe, sprinkled with the same stars. Alone among the figures in this scene, she and her child commune in joy. Another way of putting it would be that only Mary and Jesus accept the full reality of that great golden star in the heavens. Its center is marked with the IHS emblem, an abbreviation of the name Jesus. Jesus has become Mary's star, her sun, her reality. That sweet and smiling face expresses the meaning of Christmas with a childlike directness (we may have little time to look at her at Christmas, so let us look now).

It is difficult to see the crib straight, or to get the stable in proportion, clouded as it all is for us by reminiscence and custom. At every Mass

we celebrate anew this gift to us from God. At the Mass we are taken into the sacrifice of Jesus where he offers all that he is to the Father and shares with us his very being.

It seems to me that here, in this stable, Mary acts as a priest, putting before us the reality of Jesus and summoning us to share in it. In this village icon, she is not lost in contemplation, intent upon her son. Rather, she is joyously aware that he is for the world, he is for us, and she beckons us forward. Tightly swaddled, white on a gold paten, Jesus is as helpless physically as in the Host. Mary adores him and offers him and exults in him.

Teilhard de Chardin said that the infallible sign of the presence of God is joy. What I love in this picture is the joy, Mary's joy. Notice, though, that she is kneeling: Unless our hearts are still, unless we pray, we will not be aware of such joy. Joy is not exuberance of spirit, nor is it a feeling of well-being. Temperament and a good digestion have more to do with those pleasant emotions. But joy comes from the deep, unshakable happiness of faith in Our Lord. That is Mary's joy, and neither violence nor grief can destroy it.

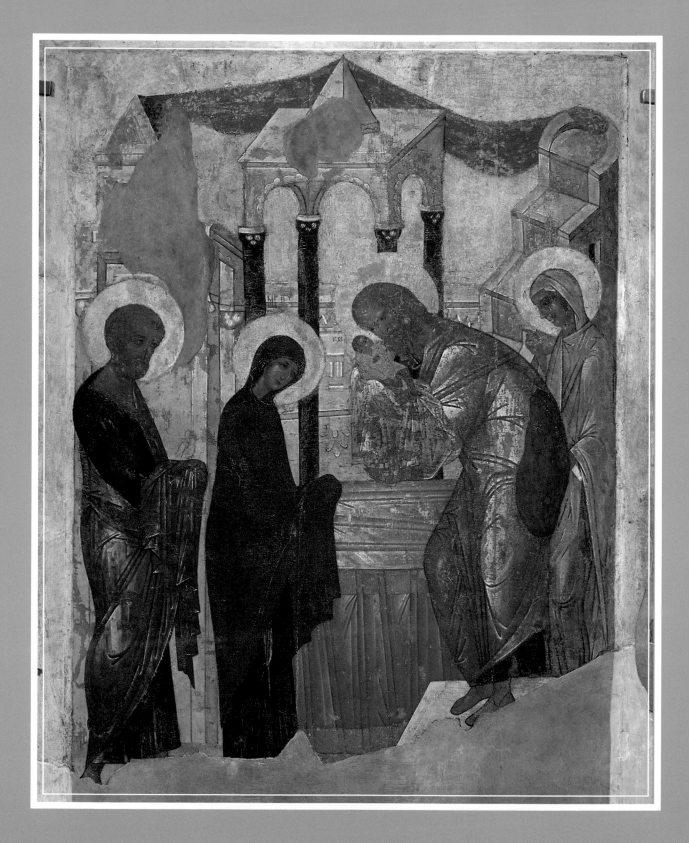

THE PRESENTATION OF JESUS AT THE TEMPLE

Presentation of Jesus at the Temple, 1408, Andrei Rublev and assistants
Russian Museum, St. Petersburg

This icon, extraordinary in its peaceful harmony, was painted for the cathedral in Vladimir by the greatest of all icon painters, Andrei Rublev (and his assistants). Rublev has been canonized by the Orthodox Church, and one cannot help but feel that the mind behind this painting was profoundly contemplative.

In the Jewish law, a woman was forbidden to enter the Temple until forty days after childbearing. After this time she came to be purified (let us not explore the thinking behind such a rule). When she had been purified, and of course this was purely a legalistic requirement with no moral implications, the mother of a firstborn son was required to offer him to God. He was "ransomed" by a symbolic sacrifice. In the case of the poor, which applied to Mary and Joseph, this symbolic ransom was "a pair of turtle doves or two young pigeons."

Rublev blithely ignores the potentially misogynistic aspect of this purification and focuses solely on what matters: the offering of the child to God. Joseph stands behind Mary with his hands veiled. We see

two parents seriously and devotedly offering to the Father their small child. We see, too, Simeon the priest, who receives this offering, and behind him Anna the prophetess, who understands at once the wonder of what is occurring. The old man holds the child right up to his face.

Simeon has sought God all his life and he is now on the point of leaving it. Holding the child, not in his hands—that would be over-familiar—but in the liturgical cloth, he looks eye to eye into the face of Jesus. We know what bursts from his heart, that great hymn of gratitude, expressing his readiness now to die, "for my eyes have seen the salvation." Mary is a witness, bowed in reverence. The encounter between Simeon and Jesus is between them alone.

The significance here is the complete acceptance of the parents that their child belongs to God. Of course, he is the Son of God, but Mary's obedience to the law goes deeper than this. Her gentle acceptance of Simeon's right, as priest, to take Jesus from her and hold him up to the Father, recognizes the state of every child.

No baby belongs to its parents; every baby belongs to God. The seriousness of Mary and Joseph underlines the responsibility of parenthood. Anna and Simeon are overjoyed at what God has done

for God's creation. Mary and Joseph share that joy, but theirs is a far more complex response. They have to make sure that the child is guided and nurtured into the full depth of his vocation.

Of course, no child has ever, in any sense, paralleled the course through life of Jesus. That is how it should be. In its own unique fashion, every child is called to fulfill his or her special destiny, of which the parents are wholly ignorant. All that is certain is their vocation to put the child first, and their own needs and desires second.

Speaking as an outsider, one who has never had a child, it seems to me the spiritual demands of childbearing are so heavy that no one could fulfill them without the help of God. Every aspect of Joseph and Mary shows forth what St. Andrei Rublev understood: that these two, above all parents, did indeed seek the help of God. They are here praying in the Temple, surrendering their child and receiving him back as a sacred responsibility.

We, fortunate Christians, have more than the Temple: We have the Church. We have the Mass and the sacraments; we have the strengthening grace that rescues parents from selfishness and can set them free to lead their children into the light of God.

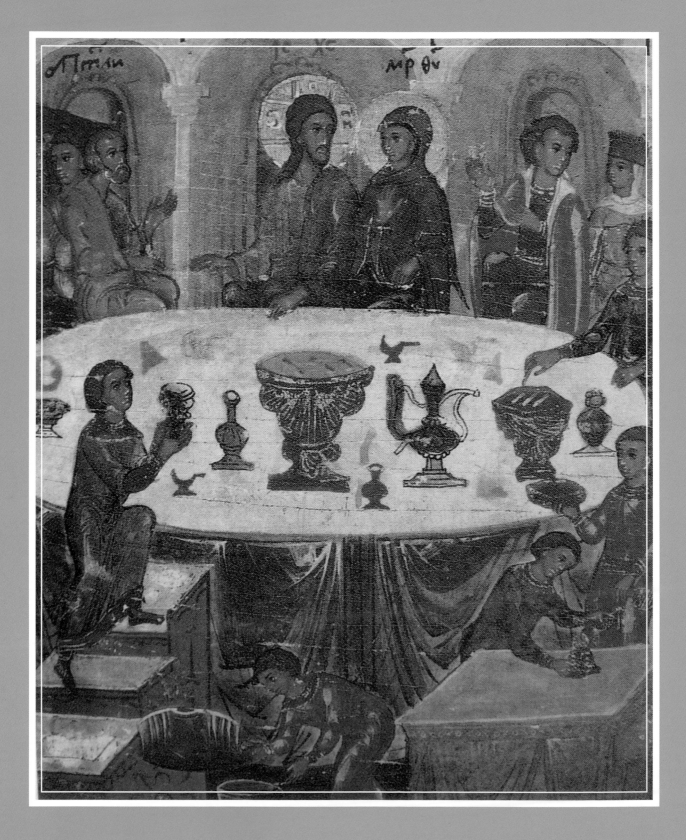

THE WEDDING AT CANA

The Wedding Feast of Cana, sixteenth century
Vologda State Historical, Architectural and Art Museum, Russia

We know so little about what we might call the ordinary life of Jesus and his mother. What did they talk about? How deeply was she involved in his mission? She had lived with the Good News, the Gospel, since girlhood: Did they ponder together the extent of its implications?

We have one small glimpse into their relationship, a vignette, a sort of snapshot, and it took place in the little town of Cana. We tend to make all the events of the Bible into sacred happenings, weighty with significance. But this was just a social occasion, son and mother being invited as guests at a local wedding. What transformed that pleasant afternoon into a revelation of God's love was the minor social scandal that was about to befall the young couple: how the local gossips would seize upon it! The wedding wine had run out. (It has been suggested that it was Jesus bringing his apostles with him that overstrained the hospitality of the young hosts.) Our Lady asks her son to save bride and groom from embarrassment.

He tells her, "It is not yet time for miracles." She takes no notice and asks the waiters to do what her son tells them. In St. John's story, Jesus tells them to fill with water the six great jars that are there for ritual purification. As we know, when it is tasted, this water has become the finest wine. Scholars point out that six large jars would provide an enormous amount of wine, because, of course, God does nothing by halves. If wine is needed, God will supply it in fullest measure.

It is the delicacy of this miracle that makes it so appealing. Jesus is not healing blindness or raising from the dead. He is simply saving a young couple from the results of their poverty or imprudence, or even from the unexpected number of guests. In this icon, bride and groom are at the far right, and at the bottom left, stepping up to the table, is the waiter with the brimming cup. The center is fully given to Jesus and his mother. They are in communion. She knows, even before he knows, what he will want to do.

St. John, in his Gospel, sees this as a crucial moment: the first of the miracles Jesus wrought. For us, its significance is complex. It shows the closeness of Jesus and Mary; it shows the great sign of God's generosity. It shows that Jesus could only reveal this generosity

because the waiters, despite the apparent irrationality of the action, did what they were told and filled the great pots with water. Without their obedience, there would have been no wine.

But perhaps for us its meaning is most to be found within its context: Jesus blessed a marriage. We live in a time when marriage is undervalued. "Partnership" is taken as an equivalent: If a couple live happily together, do they need a ceremony? But marriage is a sacrament; it offers the couple the strengthening grace that Jesus died to make available to all who need it. Who needs it more than a man and a woman struggling to become "one flesh," each complementing the other? There were to be many remarkable miracles in Our Lord's life, but this humble, almost unnoticed miracle is as precious as any.

Marriage begins with the wedding but does not end there. In itself, marriage can be seen as a symbol of the union between God and humanity. It is a very profound sacrament. Man and woman marry and, in entrusting themselves to one another, they are speaking of an even deeper mystery, that of the marriage between Jesus and his Church.

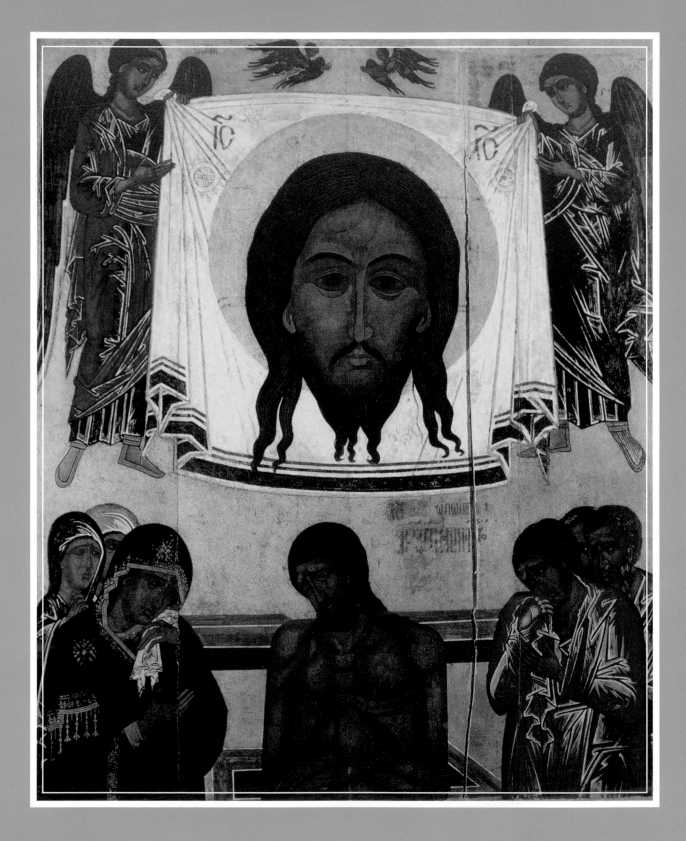

THE PASSION AND DEATH OF JESUS

Christ "Not Painted by Human Hand" and "Do Not Weep for Me, Mother," c. 1570, School of Moscow

District Museum of Kolomenskoye, Moscow

This icon unites two images. The larger, dominating image is that of the face of Our Lord that was imprinted on the cloth Veronica handed to him as he passed by on his way to Calvary. It is called "Acheiropoietos," which means "not painted by human hand." But below the whiteness of the cloth, we see an image of Jesus dead, with St. John, Joseph of Arimathea, and Nicodemus grieving on one side, while Our Lady and the holy women lament on the other. This particular image has its own title, "Do Not Weep for Me, Mother," because, of all those who grieved over the suffering and death of Our Lord, no one knew the depth of suffering as did Our Lady.

When she offered Jesus in the Temple, as a child, Simeon told her: "a sword will pierce your own soul too," and there are many artistic representations of that pain. We see her standing weeping at the cross, receiving her dead son into her arms, almost dying of grief as she watches him being laid in the tomb. There is surely no human being who has not known suffering, and it is one of the great mysteries of life. What do we do with pain? Why does God "allow" it? What is its significance?

This icon tries visually to put into sacred perspective this insoluble mystery. Jesus tells Mary not to weep for him. Yet surely, if there was ever a clear-cut case for grief, it is the crucifixion of her son. Not only is a mother losing her only child, but also a woman of immense faith is seeing the rejection of her God. The anguish is real; it cannot be avoided or made light of.

Jesus does not ask his mother to ignore or try to escape from pain; he asks her not to weep. The image shows why. It was through the dereliction of death that Jesus saved us. Until he died, we were not redeemed; and it was the very pain of this death, its blood and sweat, that imprinted on the cloth the glory into which he has entered.

The cloth shows the image of the Risen Jesus, and it is to that he directs his mother's attention. Pain is meant to be fruitful. If we stay in it, lamenting, we are frustrating its potential. "Lift up your eyes," says Jesus, "see the glory to which I have come through the cross, a glory that is for all of us to share."

Over the years, Our Lady must have seen deeply into the problem of suffering. Because of her closeness to God, she would always have known that God does not send suffering. It is never "God's will" that we suffer. God's only desire is for our happiness.

Jesus told his apostles that he came to bring us the "fullness of life," but the actual world we live in forces suffering on us. There are accidents, disease, violence, natural disasters, and human aggression. There are painful misunderstandings; there are all the small bodily malfunctions that can make life a misery. Jesus did not escape them, nor did his mother; but what Jesus says to us, and what Mary must have fully comprehended, is that we are called to take up our cross and follow him.

When we take up the cross, we accept its reality and its harshness, but we make use of it. Jesus used his cross to redeem the world. Here he is telling his mother to use her heartbreak, her cross, to redeem her little world. Mary would have understood, at great depth, that suffering can turn us in on ourselves and diminish us, or it can turn us outward toward God, to an unimaginable fulfillment.

Always, above the vision of his tortured body, Mary would have seen the vision adored by angels, of her son in glory. It was in the mysterious meaning of suffering that she would have dwelt, a meaning that is accessible only to faith.

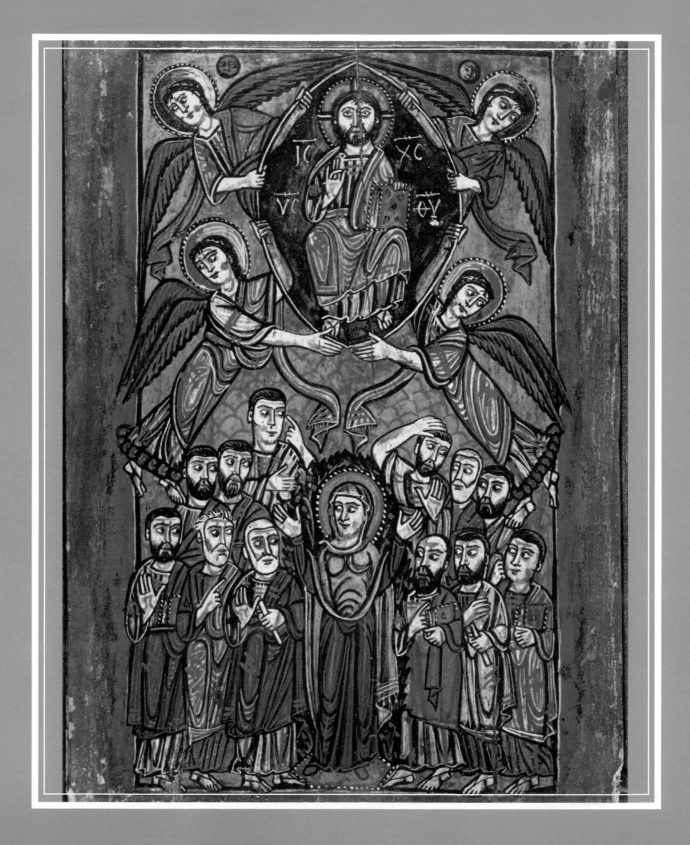

THE ASCENSION

The Ascension of Christ, ninth or tenth century
Monastery of St. Catherine, Mt. Sinai, Egypt

St. Luke writes twice about Christ's ascension: briefly at the end of his Gospel, where he tells us that the apostles returned to Jerusalem filled with joy, and in much more detail at the beginning of the Acts of the Apostles. In neither account does he mention Our Lady, and the conclusion must surely be that she did not venture out to the relative wilderness with the stalwart band of the apostles.

Yet early Christian art, of which this icon is a delightful example, consistently sees Mary at the center of the group who witness the ascension of Jesus into heaven. Obviously, the Church thought she ought to be there: this was very much her concern. This is a relatively unskilled icon, but intently alive. The apostles, including a rather apprehensive Peter at Our Lady's right hand, and a quite anachronistic Paul at her left, have that vapid look of men who have lost their bearings. They knit their brows, they raise astonished hands, they exchange worried glances. Even St. John, on the far right as we look, grasping the Gospel he will one day write, is deeply perplexed.

For some reason they cannot respond to the comforting presence of the angels floating so close to their anxious heads. Their whole emotion is of distress and confusion. After forty days, Jesus has gone. He has gone into his glory, as we see him being borne triumphantly aloft; but, for the apostles, gone is gone. Their faith is still perilously weak. He had told them that he would not leave them orphaned, that he would come back to them, that he would send them a Paraclete, a Comforter. He had told them he would be with his Church "until the end of time." Yes, but now he has ascended, and they can no longer see him. The apostles are in a very sad state of disarray.

Here is where the instinct of the Church feels it necessary to introduce the presence of Mary. The icon painter has set her upon a little raised stool as if subtly to indicate that, physically, she was not standing with the apostles on that hillside. He has also painted her larger than life-size, and her position is that of the woman praying, the Orante. Her arms and the hem of her cloak form a symbolic chalice, and although it is technically empty—Jesus has ascended—he is mystically always with her.

This is not a beautiful and tranquil Madonna. With her plain features and the heavy breasts of the elderly, she is a comforting maternal presence. The eyes of her twelve sons turn to her, questioning, frightened. Mary's gesture is of reassurance and comfort. The angels have asked the apostles, "Why do you stand here looking up to the sky?"

Mary embodies the answer to that question. It is fruitless, indeed, to stand gazing heavenward. Jesus is not in the skies, he is within us. Although it will be painful for them, and for her too, no longer to see him and hear him, he is no less really present. The Eucharistic Jesus is as much with his Church as Jesus was with his mother or his disciples.

Mary is drawing the Church back to the reality of Jesus. We cannot love him and preach him if we are unwilling to accept that he now lives among us, in another fashion. Once he was in Mary's womb, as the hem of her cloak reminds us. Once he walked the hills of Galilee, as those large sandaled feet remind us (in contrast Mary has small feet in pretty pink slippers). She is there as a witness to the continuing reality of his presence. If St. Luke's Gospel is right in telling us that after Christ's ascension the apostles returned to Jerusalem "filled with joy," it was because of Our Lady.

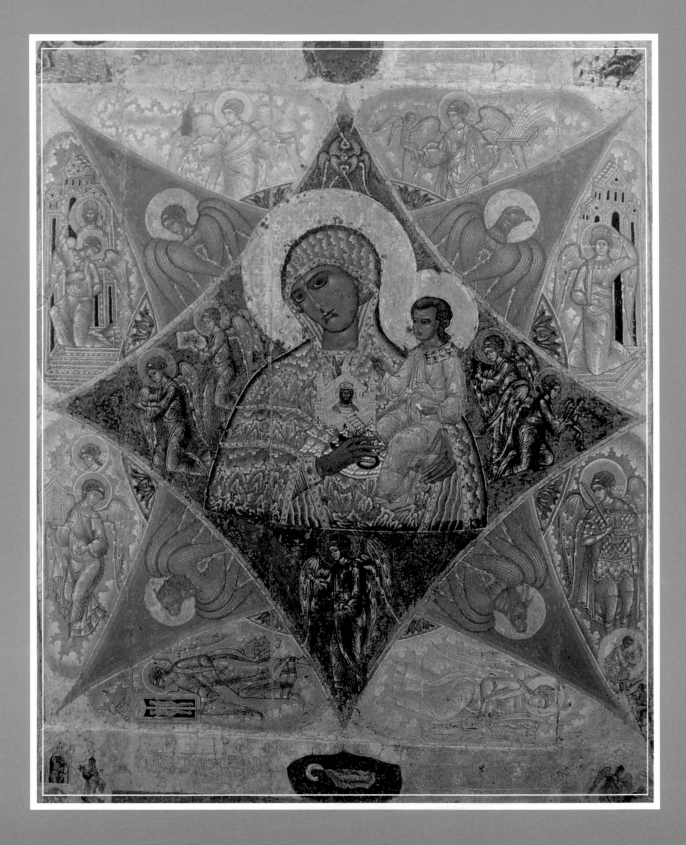

THE VIRGIN MOTHERHOOD

The Mother of God as the Burning Bush, sixteenth century, Monastery of Solovki

District Museum of Kolomenskoye, Moscow

Since the third century A.D., there have been holy men praising God at the foot of Mt. Sinai. The Holy Monastery of St. Catherine is the oldest inhabited place of Christian prayer in the world. The bleak crag that overhangs the monastery calls the monks to remember always that it was here on Mt. Sinai that God gave the commandments to Moses, and it is believed that it was here that Moses encountered the burning bush.

In their meditations, the monks came to see the burning bush as an image of Our Lady, and this is what this icon holds before us. The eight-pointed star indicates the presence of the Lord of hosts, the Ancient of Days, the green-blue alluding to the bush and the bright red to the burning of the divine presence. There is one shape, but it is both material and spiritual; and this, of course, recalls the body and soul that the Lord took upon himself in our human nature. The bush burned but was never consumed, and this too seemed almost a prophecy of Mary's virgin motherhood, two contradictions resolved in one.

So at the heart of the great star is Jesus, small but regal in his mother's arms. It is a complex image, because we can also make out in the center other symbols: there is a ladder, since the incarnation joined heaven and earth; there is a rock, hewn from the mountain, symbol of

the unshakable presence of God; and there is a tiny representation of Christ the high priest celebrating the Eucharist on the altar of his tomb in Jerusalem. The icon is telling us that the Church contains Jesus, just as Mary did, and this complex imagery is held in her heart.

In the red points of the star, we can see the symbols of the four evangelists, the four winged creatures: We go from St. Matthew's angel in the upper left clockwise through St. John's eagle, to St. Luke's ox and St. Mark's lion. But the clouds in which the great star is set are also filled with images of the angelic choirs holding stars, bolts of lightning, torches, swords. We see guardian angels at their task, and there is an overwhelming impression of an active world of angelic presence, focused on Mary and on her son, and spreading out to the world.

Outside the central image, symbolism continues, giving us four small incidents from Scripture that foretell the miracle of the virgin birth. At the upper left, most prominent, is the actual burning bush, with Moses on his knees before it. In the center gleams Mary. On the upper right, we see the seraph who held a burning coal to the lips of the prophet Isaiah to purify him. Below Isaiah, on the bottom right, we see Jacob, the biblical hero who fought with an angel, here falling vanquished. More importantly, above Jacob, who is now in exhausted slumber, the angel sets up the ladder of which Jacob dreamt. On this

ladder Jacob saw angels ascending to and descending from heaven, another foreshadowing of the coming to earth of the Son of God.

In the bottom left corner, we see the Temple in Jerusalem, with the great door of the sanctuary that is shut. Ezekiel stands before it, understanding the prophecy of the virginal womb, the closed door, through which God will come to live among us. Jesus waits: His mother has not yet been born. At the bottom center is a small picture of Jesse, from whose body will spring the genealogical tree of Mary's ancestors, culminating in the glory of Jesus.

This is a difficult icon to write about, because its significance is so complex. Once we translate poetry into prose, some of the magic will always be lost. The Church has constantly been drawn to praise Our Lady in poetic terms: Think of the titles we sing in the litany. Mary's unimaginable closeness to her son fills us with wonder. Yet she was a simple human being, just as we are. God could do such great things in her because she gave God absolute freedom. This intimacy with God seems to call for an extraordinary language and to require an extraordinary visual image.

Perhaps we come closer to the poetry if we just dwell silently in our hearts on the thought of the desert and the bush alight with flames, and yet still green and fruitful. Or it could be that we understand it better without words and the precision of pictures.

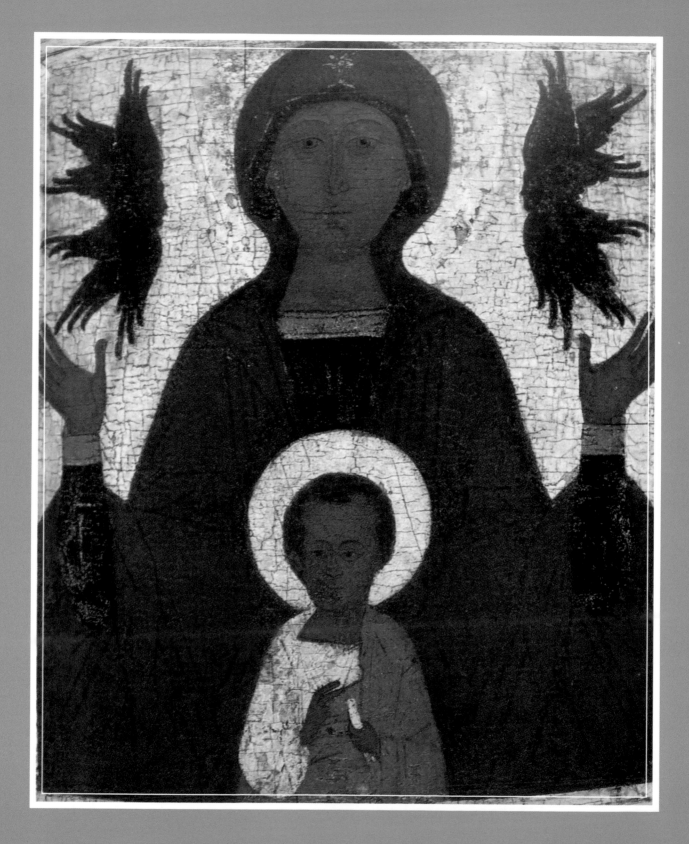

MARY AT PRAYER

The Virgin of the Sign, mid–sixteenth century
State Historical Museum, Moscow

In the Roman catacombs, the Church uses an ancient image of the soul waiting for the glory of eternal life. It shows a woman with uplifted arms and the palms of her hands turned towards heaven. This figure was called an *Orante*: It represented prayer; it represented hope and the faith that could strengthen the Christian to martyrdom. As time went on, the woman who was central to Christianity, Our Lady, became identified with this figure of prayer.

When the monks at St. Catherine Monastery at Mt. Sinai depicted Mary as the burning bush, they painted a bright circle at her heart, in which stood Jesus. This is a simple and sober icon, and it is not meant realistically. Mary is not holding her child; this is not Jesus as we see him in the Gospels. This is the mystical image of Christ Emmanuel. This is the Word who existed from the beginning and who came into our time through his holy mother. Isaiah prophesied: "The Lord himself will give you a sign. Look, the young woman is with child and shall bear a son, and shall name him Emmanuel"—a name that means "God is with us."

This small Jesus is the lawgiver, the king. With one hand he blesses us but with the other he holds the scroll of his Father's law. Mary is, as it were, his witness. The hands she lifts in prayer suggest that Jesus is held within a chalice (her arms down to the unseen hem of her robe make the shape of a great cup), offering himself to the Father for the salvation of the world. If those upheld hands suggest a chalice, they also suggest wings. Her hands are open to receive the presence of God and this is emphasized by the wings of the cherubim spread out on either side.

Our Lady's face is impassive. She seems to want to obliterate herself from our consciousness, eager only that we should look at Jesus—Emmanuel. Her very essence is prayer, is intercession, is surrender of all that she is to the grace of God. We tend to think that this is the ideal of prayer, which none of us can be expected to reach. Yet when we were baptized, the Trinity itself took up residence in our spirit; and the Word of God is always present, to be spoken through our lives, as he was so perfectly through Mary's.

It is not because we are holy that the Lord gives himself to us, but simply because he loves us. He wants to draw us into the happiness and

freedom that his mother knew. We see her here motionless, holding up her arms in intercession. That prayer of intercession did not stop when Mary stirred the family soup or washed Joseph's work shirt. That was her attitude, her constant intention. Her heart held her before God, and all the activity of a working day, and the natural pleasures of family life, were no obstacle to that attitude of prayer.

When the priest tells us: "Go, the Mass is ended," he does not mean that the essence of the Mass is used up or finished. We who go from the church go with the Mass within us. We are people-who-have-been-to-Mass, and the warmth of that sacrifice stays with us. "Our Lady of the Sign" is a sign that was not just for Isaiah but equally for us: she is a sign of the constant presence of God with us, Emmanuel, and of the gift that has been given us, to live within the brightness of that sign.

Notice how Our Lady in this icon does not look at her son. She looks obliquely out at the world. She does not ask to see. She accepts that her hands are empty. She is aware that the small Jesus is not here in the beloved role of her son but in that of the second person of the Blessed Trinity. The suspicion is, from this icon, that she feels little warmth or comfort; Mary is lonely. No matter: She glories to raise her hands in prayer. This is our noble mother, Mary.

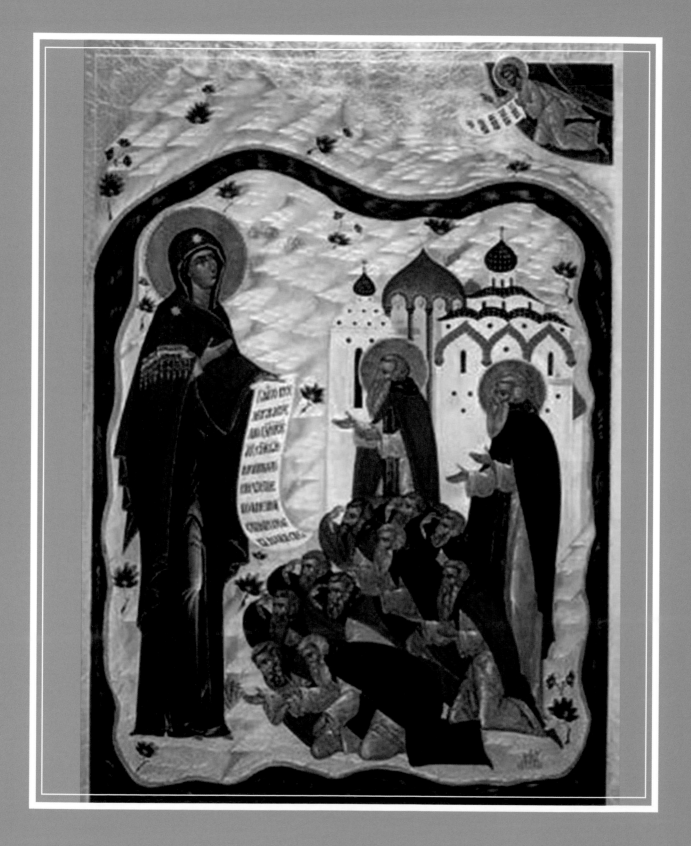

Mary, Our Intercessor

The Virgin of Bogoliubovo, 1545, Monastery of Solovki
The Kremlin Museum, Moscow

In 1157 Prince Andrei Bogoliubskii had a dream so vivid that he regarded it as a vision. Our Lady appeared to him, holding a scroll with petitions on it and making a gesture of pleading to her son. The prince was overwhelmed by the theological truth of what he saw: how Mary receives our prayers but only so as to offer them to Jesus. It is he who answers them.

Prince Bogoliubskii built a monastery in the place of his vision and had an icon made. Monasteries all over Russia were affected by the image, and this particular icon was painted for the great monastery of Solovki. Founded in one of the most inhospitable regions of the earth, it occupies almost the entirety of a small island close to the Arctic Circle; nevertheless, it had become one of the most flourishing and extensive monasteries in the country.

Here we see at the back the strong, impressive monastic buildings, and in front of them two saints, founders of the monastery, come down from heaven to plead, together with their monks, for Our Lady's help. The monks, overwhelmed, what with visions behind and before them, are sunk in a shapeless mass of supplication. There stands Our Lady, slender and protective, larger than the two saints, larger than the massive walls of the monastery. She is barely confined by the wavy line that indicates this is taking place on an island: All around are the dark waters of the sea. But above is the glory of heaven, and this is the point of the icon.

Our Lady does not look at those who pray to her, she does not read the scroll with its petitions: It is not for her to grant or deny. No, she looks up to the golden glory of heaven where she sees Jesus, and to him she has passed the scroll. He will read it; he will respond. She is there as a loving and supportive presence, a constant reminder of the fruit of her womb, the incarnate Son of God.

The words "fruit of your womb" come, of course, from Scripture, part of the praise offered to Mary by her cousin Elizabeth. We are familiar with them from the Hail Mary. In the first half of the Hail Mary, we join in the praise of the angel Gabriel and then in the heartfelt admiration of Elizabeth. This first half of the prayer simply expresses the wonder of both angels and humans at who Mary was and what she did. It is in the second half, composed by the Church, that we actually pray to her. But notice what we pray for. In the Our Father our demands are clear-cut: give us, forgive us, lead us not. But all we ask in the Hail Mary is that Mary should pray for us.

Like us, Mary is a creature, even though of incomparable holiness. She grants us nothing, but we have only to ask, to make the smallest movement toward her, and she joins her voice with ours. The icon

makes it beautifully clear that Jesus has the monks' petition safe in his hands.

It was a fraught time for the Solovki Monastery. Shortly their great Abbot Philip would become Metropolitan of Moscow, the highest position in the Russian Orthodox Church. It was a perilous promotion because, as the monks well knew, this was the age of Ivan the Terrible, when no one of independent mind was safe. Ivan killed Abbot Philip, and the monastery fell upon hard times. Worse was to come centuries later, when the Bolsheviks came to power: The monks were ejected and the monastery became a political prison, a gulag. Only in our own time has the persecution ceased; the buildings have been returned to the Church and the monastery has become once more an active center for prayer.

This history has its significance, in that it might seem the petition we see here, offered with such earnestness, was not granted. They prayed for safety, but in vain. Yet, from our historical viewpoint, we can see that it was indeed granted, and that the new Solovki, purified and strong, has only gained spiritually through the years of suffering. No prayer to Our Lady ever goes unanswered, because she hands it on immediately to her divine son.

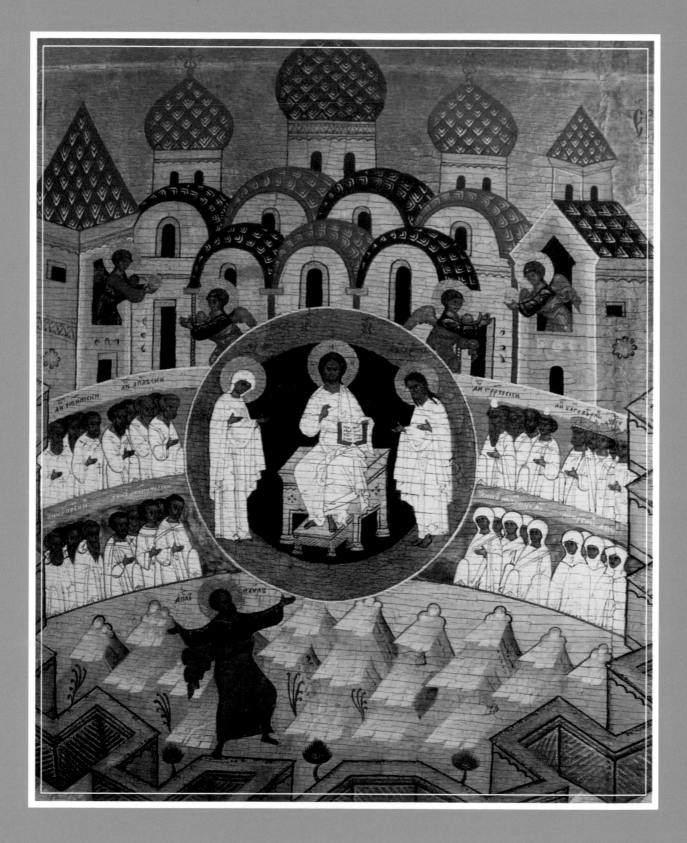

MARY, FIRST SAINT

The Vision of St. Paul, c. 1579

Museum of History and Art, Sol'vycegodsk, Russia

Each year, on the feast of All Saints, the Church celebrates the heavenly Jerusalem, that resplendent city in which are gathered the souls of all who have served God and entered into God's happiness. Since no one has been to heaven and come back to describe it to us, our images of this extraordinary place come solely from visions of the prophets.

In his book of Revelation, also called the Apocalypse, St. John describes the wonders of that city: its jeweled gates, its broad and blessed rivers, its peace and its joy. But there was also a work called the *Apocalypse of St. Paul,* a book of revelations attributed to the apostle. It was not accepted into Scripture, and it was not written by St. Paul, but by somebody who felt he had entered into Paul's thinking and could tell us what St. Paul would have told us, had he had the vision.

This all sounds rather dubious, and yet the icon of the vision of St. Paul is a most beautiful depiction of the wonder of being a member of the Church sanctified. In his letters, St. Paul speaks of having been lifted up into the heavens, and here, at the bottom, we see him. One foot is in heaven and one foot on the elaborate golden walls. Around him are rocks, the dangers and the trials that the blessed inhabitants of heaven have passed through and passed over, so as to stand in shining garments before the throne of God.

Central, of course, is Jesus, whose very presence makes any place heaven. He is seated on a golden throne, hand raised in blessing, holding the book of his Good News. Naturally, there in that golden circle is Mary, radiant in white, arms outstretched in longing, as she contemplates the glorification that is her son's. Even John the Baptist, on Our Lord's other side, has lost his camel's skin and shines as brightly as Jesus and Mary. He represents the old law, all those who have served God through the countless ages before the incarnation. Mary, of course, represents the new law, the Church.

The lines of saints show the apostles, bishops, prophets, and kings, men and women martyrs and confessors. It seems appropriate that we are more conscious of their numbers than of their names. All Saints is not a feast that is primarily in honor of the canonized saints, but of those millions of others who have died in the grace of God.

We tend to think that we ourselves, and most of those we know, will rank as All Souls rather than share in the glory of All Saints. But the end of every creature is meant to be heaven, and so great is the goodness of God that there is no reason why every one of God's children should not eventually be purified from earth's grubbiness and

tatters, and receive the pure white robe of holiness. Behind the waiting rows of saints, we see the domes and spires at the heart of heaven, with angels passing out golden haloes to set upon every human head.

From all Jesus said, it seems clear that the one condition of heaven is that we have loved. Some of us, to our shame, know that we have loved very little and very poorly, and I think that is why we need to see Our Lady there with Jesus at the center. He is the source of love; but she was the one, above all, who received it. She shows us what the power of God can accomplish. She placed herself among the lowly, the poor, because she knew that she possessed nothing. It was this very poverty that made her able to receive everything from God. She is the living proof of God's sanctifying love.

The icon shows St. Paul wondering at what he sees. In the Apocalypse, St. John describes the city as "lit by the radiant glory of God." All St. Paul's teaching stressed the infinite power of that glory if we can only accept our helplessness and let God be God to us, as he was to his mother. Paul never refers to Our Lady by name, but she seems to be implicit in all he writes.

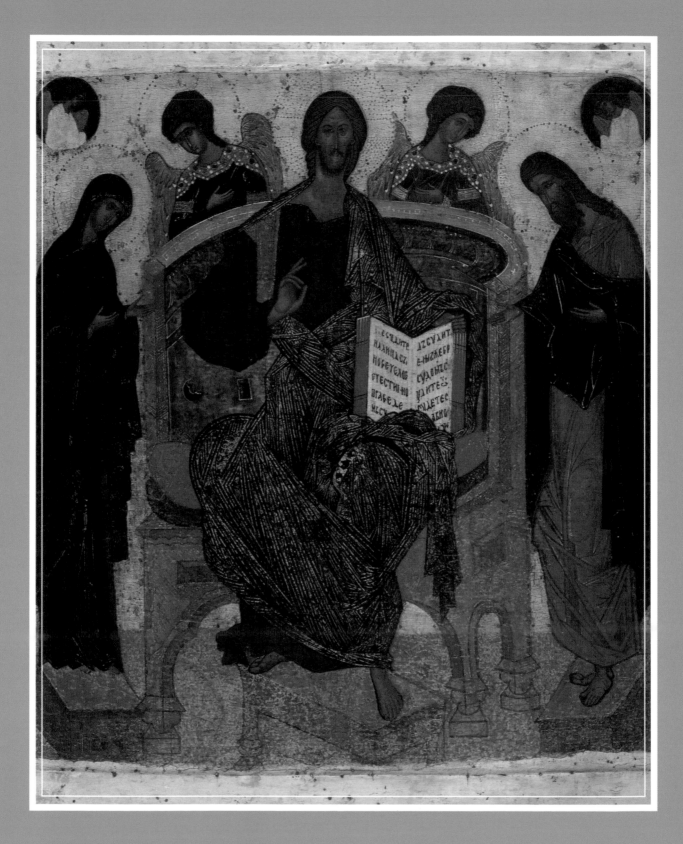